How to draw
MANGA
MALE ACTION FIGURES

Peter Gray

W
FRANKLIN WATTS
LONDON·SYDNEY

This edition printed in 2006

First published in 2005 by
Franklin Watts
338 Euston Road
London NW1 3BH

Franklin Watts Australia
Hachette Children's Books
Level 17/207 Kent Street
Sydney NSW 2000

Produced by Arcturus Publishing Limited
26/27 Bickels Yard, 151–153 Bermondsey Street
London SE1 3HA

© 2005 Arcturus Publishing Limted / Peter Gray

Editor: Alex Woolf
Designer: Jane Hawkins
Artwork: Peter Gray
Digital colouring: David Stevenson

A CIP catalogue record for this book is available
from the British Library

ISBN 07496 6619 6

Printed in China

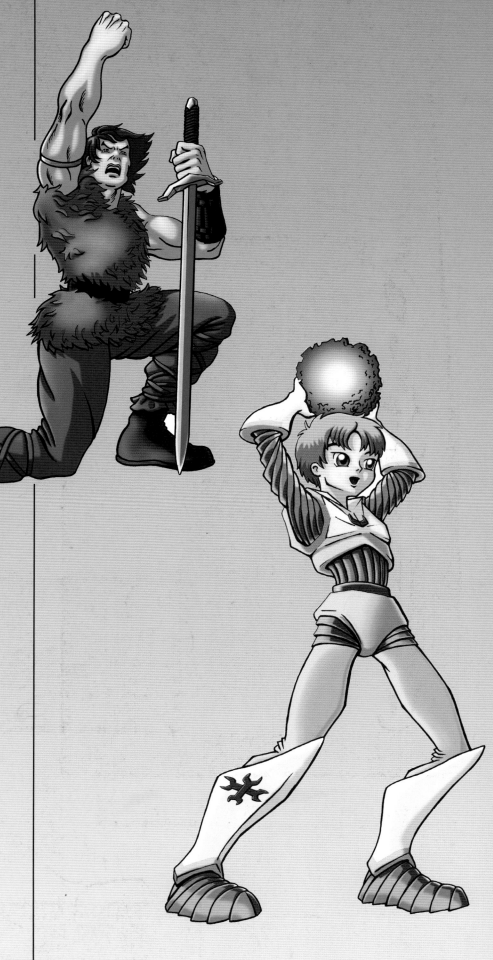

Contents

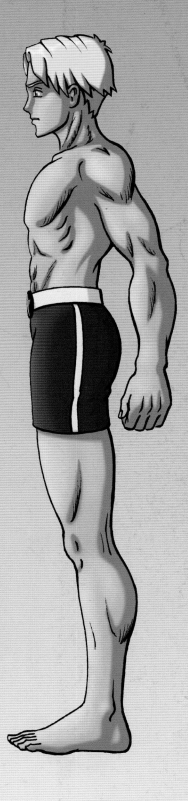

Introduction

This book shows you how to draw the types of action characters that have taken the comic world by storm in recent years and are the stars of Japanese animation (known as anime). Called manga, this style of artwork was first used in Japanese comic books. Manga is, in fact, the Japanese word for these original publications.

The style is very distinctive – dazzling eyes, angular features, simple but often exaggerated expressions, extreme gestures and super-slick colouring.

Every manga character you see in a TV programme, movie, comic or computer game starts life in exactly the same way, as a rough sketch. The artist then turns this into a black line drawing. Colour is added later.

In this book, we'll be focusing on how to draw manga male action figures. Follow all the step-by-steps and advice given in this book, and you will soon learn all the techniques you'll need to draw them. But drawing manga is about more than just absorbing the theory. To draw well in the manga style takes a lot of practice, so be prepared for some hard work, but a whole lot of fun, too. Once you've built up your skills, you'll be able to create your own original characters, and then there'll be no limit to the possibilities ahead.

You never know – one day your creations might make it onto the screen or published page!

Duke

This is good guy Duke, and he'll be helping to demonstrate some of the drawing lessons in the book. You'll also come across several other characters from his world.

Duke is 17. He has more muscle than most ordinary teenagers, but he only uses his strength when he has to. He is thoughtful and a bit of a daydreamer.

Materials

As long as you can lay hands on a pencil, an eraser and some plain paper, you can do the exercises in this book. It will help you to use pencils of different hardness at different stages of your drawing.

Pencils are graded H, HB or B according to their hardness. H pencils are the hardest. These pencils will make lighter lines. B pencils are softer and will make darker lines. Most general-purpose pencils found at home or school are graded HB. Use a hard pencil, like an H, for sketching the guidelines you'll be drawing to help you shape your characters; using this pencil ensures the lines are easily erased later. Use a softer pencil, like an HB or B, when you're ready to pick out all the final lines of your drawings to darken them. Mechanical pencils are best, as they produce a constant fine line. If you're not using a mechanical type, make sure you keep your pencil sharpened.

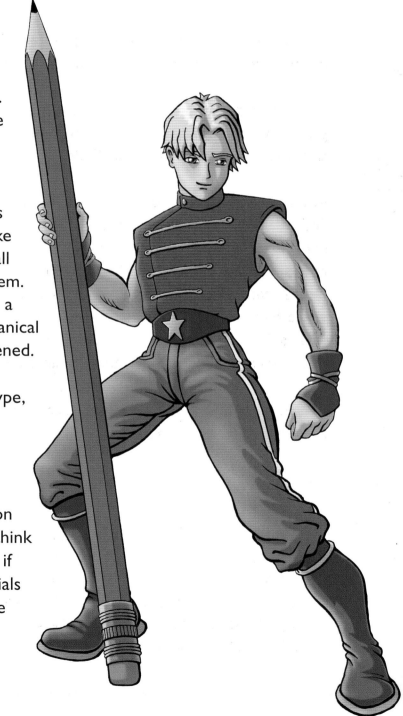

You'll also need an eraser. You can use any type, but make sure it doesn't leave dirty marks.

You can use any odd scraps of paper to make your initial sketches. Most of the pictures created for this book were drawn on cheap photocopier paper. You only need to think about the quality of the paper you are using if you are colouring your pictures using materials like watercolour paint, which might make the paper tear or buckle.

The Figure

The human body is a very complex machine with bones, muscles, fat and skin all working together. You don't need to understand its entire makeup to draw a manga-style figure, but knowing something about the structure of the skeleton, and the flesh and muscle attached to it, will help make your drawings easier to construct.

The Skeleton

The skeleton can be thought of as a frame on which you hang muscles, skin and clothing. The arms don't hang directly from the chest but are separated by shoulder bones. The legs are joined directly onto the hips. The body is able to bend because of the joints. The arms have shoulder, elbow and wrist joints, whereas the legs have hips, knees and ankles.

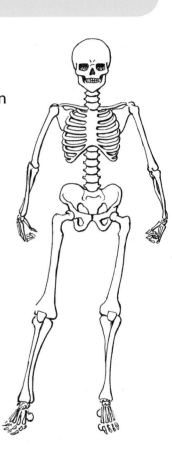

1 Front view
This is a simplified version of the front view of Duke's skeleton to show the main body parts. The joints are drawn using dots.

2 Side view
When Duke is seen side on, some of his features get thinner and others disappear from view. Notice the arch of the spine from this angle.

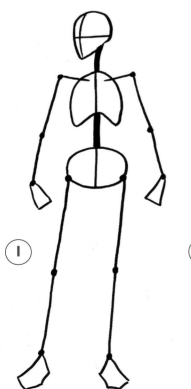

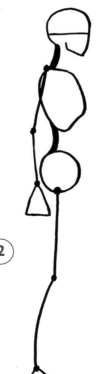

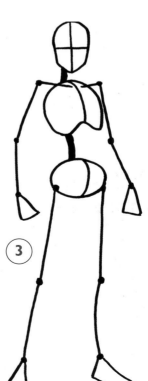

3 ³/₄ view
As Duke starts to turn towards the side, the shape of his ribcage and hips will look different again.

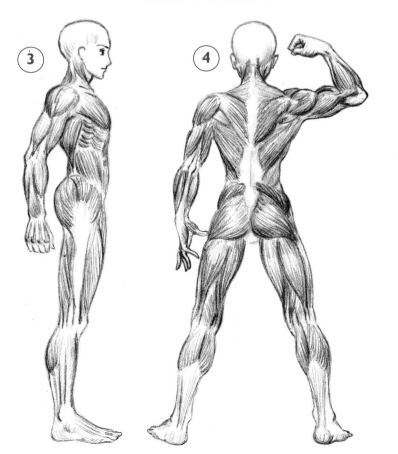

Muscles

Duke is a typical manga teenager — larger than life. A real boy of his age would probably carry far less muscle than this.

1 Body outline – front view
Duke's outline mostly follows the shape of the skeleton. It curves out more where the body is particularly muscular, and tapers in at the joints.

2 Muscles – front view

3 Muscles – side view

4 Muscles – rear view

These pictures show how the flesh and muscles wrap around Duke's bones. Understanding the muscle structure will make drawing it easier. You may like to refer to these pictures when you are drawing your own action characters.

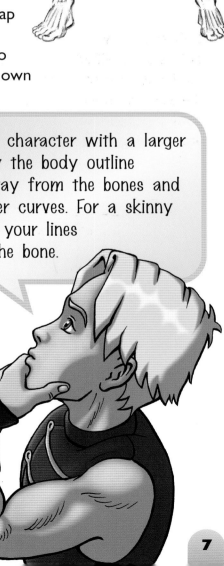

To draw a character with a larger build, draw the body outline further away from the bones and use stronger curves. For a skinny body, keep your lines closer to the bone.

Front View

This is Duke's body as viewed from the front. This is the easiest angle to draw, so it is a good one to start with.

Step 1

Start by drawing a vertical line to make your picture symmetrical. Draw the framework for the face. The chest shape is a large oval that curves in at the bottom. Now draw an oval lying on its side for the hips. The gaps in between these parts are for the neck and stomach. Add the arms and legs. Use dots to mark the joints. Draw the hands and feet as simple shapes to begin with.

Step 2

Add some rough guidelines to mark where the flesh and muscles will go. Don't worry about the joints yet. These lines curve further away from the bones around the more muscular parts of the body like the shoulders and calves.

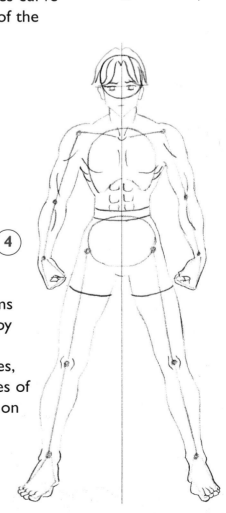

Step 3

Join up the parts of the outline you drew in the last step. Carefully copy where the lines curve inward, like at the elbows, wrists and ankles. Outline the hair and facial features.

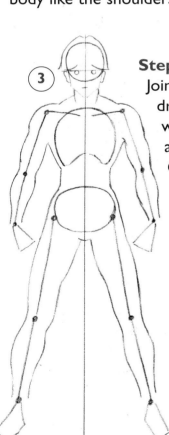

Step 4

Draw some curved lines on the arms and chest for muscle definition. Copy the shapes that form the stomach muscles. Copy the curves of the toes, feet, knees and ankles. Mark the lines of Duke's swimming trunks, and work on his face and hair.

Step 5
Go over your final pencil lines with a black felt-tip. Add some extra little lines and curves to Duke's body to highlight his muscles and bones. Add the star in the circle to his swimming trunks.

Step 6
When the ink is dry, erase all the guidelines you drew for Duke's skeleton. That's your first manga body finished!

It's important to get the shape of the feet right. They won't look realistic if you square off the toes. Practise by drawing your own feet.

Step 7
Now you're ready to colour in the picture if you want to. Notice how some parts have been shaded darker than others.

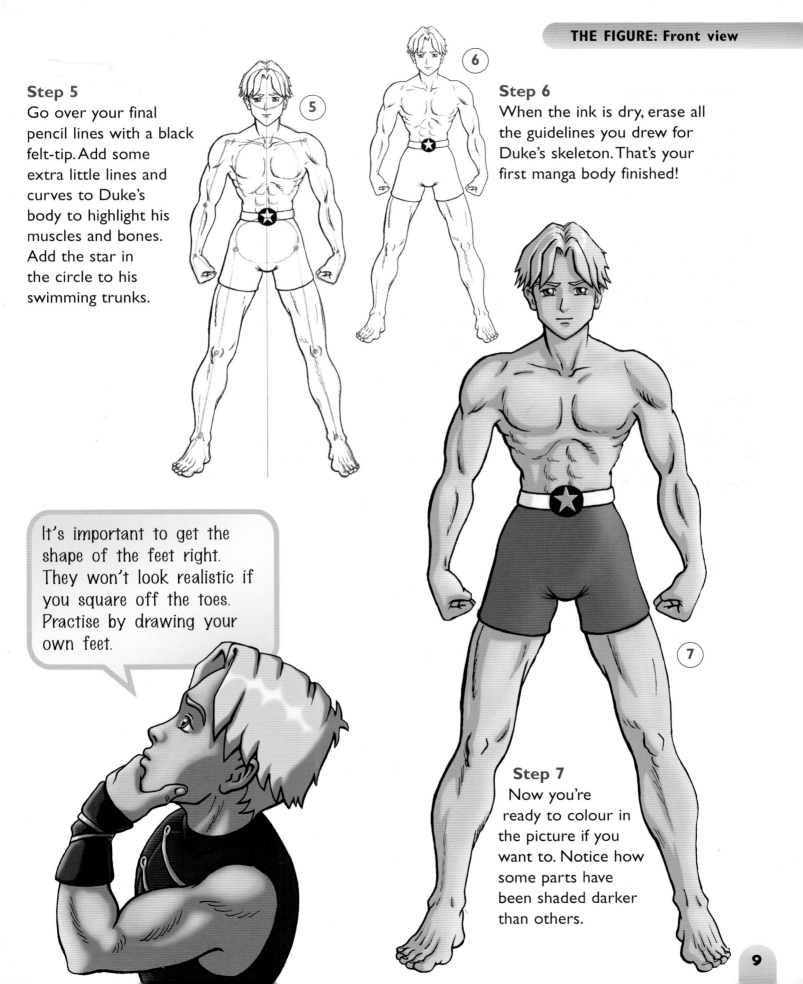

Profile

Duke has turned to the side and changed his pose slightly. When he stands like this, we can see only one arm and one leg.

Step 1
First draw the head, chest and hips. Copy the framework for Duke's head. The chest is a tilted oval shape with a piece missing near the bottom. The hips are almost circular. Add the curved lines forming the neck and lower part of the spine. Carefully copy the way the limbs are attached to the body. Curve out the calf bone on the leg.

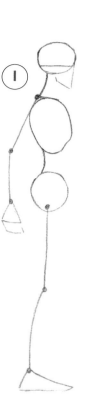

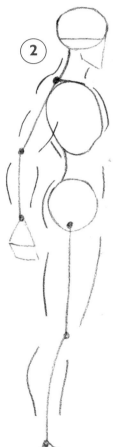

Step 2
Now for some flesh and muscle. Draw some rough lines around the main bones of the body. It's important to get these right before completing your outline.

Step 3
Once you're happy with where you've placed the main parts of your body outline, fill in the gaps. Curve the outline in and out around the joints, and draw short curves for the stomach to define the muscle. Next, outline the hair and place the facial features.

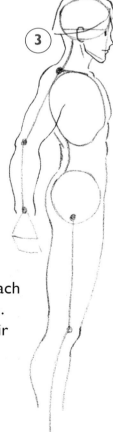

Step 4
Now add some lines to the upper body to make the muscles stand out. Shape and add detail to the hair, hands and feet. Define the knee and ankle bones. Draw on Duke's swimming trunks. Draw some extra little lines around the chest to define the ribcage.

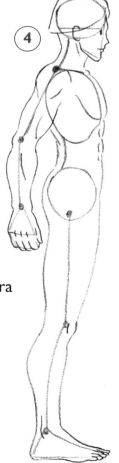

Step 5

Now go over your pencil lines with ink, adding more detail to the hair, face, hands and feet as you go.

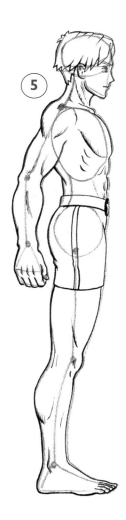

Step 6

Once the ink is dry, erase all the pencil lines of your skeleton framework to leave a clean drawing.

Step 7

Now colour in your picture if you want to. Try experimenting with different colour schemes for Duke's hair colour and skin tone.

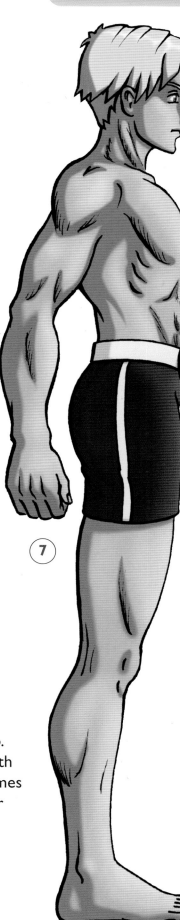

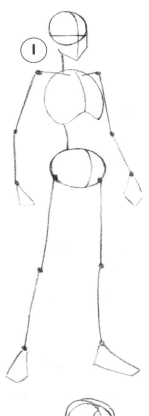

3/4 View

This viewpoint is slightly more complicated to draw, but it creates a much more interesting picture, so it's worth spending some time trying to get it right.

Step 1
Using light pencil lines, draw the skeleton framework as shown. Notice how each of the main body parts has a curved vertical line on it. The lines for the neck and lower part of the spine also curve out to the right.

Step 2
Add the main lines that mark the flesh and muscle around your skeleton framework.

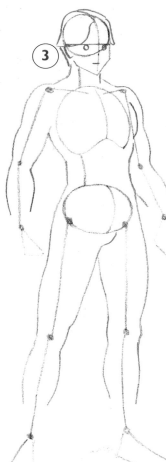

Step 3
Fill in all the gaps around Duke's body outline as shown. When drawing a figure at this angle, the line of the neck on the right is further from the spine than the other one. The same is true for the waist. Start to shape the hair and facial features.

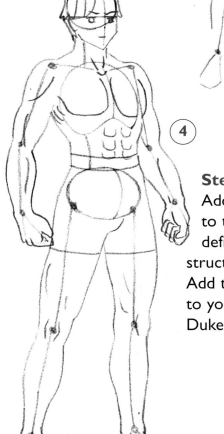

Step 4
Add some more lines to the upper body to define the bone structure and muscle. Add the hands and feet to your outline. Add Duke's swimming trunks.

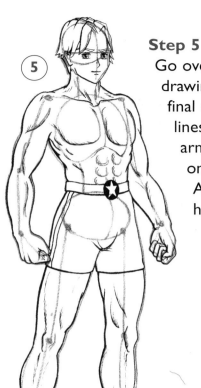

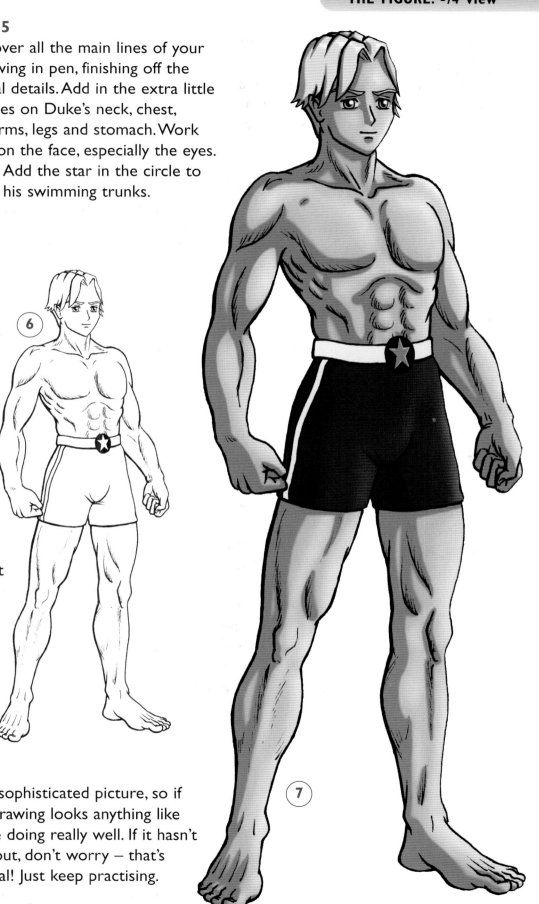

Step 5

Go over all the main lines of your drawing in pen, finishing off the final details. Add in the extra little lines on Duke's neck, chest, arms, legs and stomach. Work on the face, especially the eyes. Add the star in the circle to his swimming trunks.

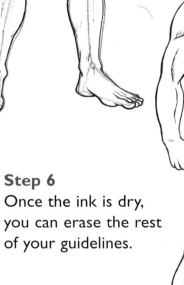

Step 6

Once the ink is dry, you can erase the rest of your guidelines.

Step 7

This is quite a sophisticated picture, so if your finished drawing looks anything like this one, you're doing really well. If it hasn't quite worked out, don't worry – that's perfectly normal! Just keep practising.

Hands

Drawing realistic-looking hands is tricky, but well-drawn hands will give your pictures an expert quality. Just like the rest of the body, they can be broken down into basic shapes. Let's start with the back of the hand.

Step 1

Draw a rough outline of the overall hand shape before adding the individual bones. Draw a large circle at the bottom for the wrist. The finger bones and joints all radiate out from this. The bones are the straight lines and the circles are the joints. The thumb should stick out to the left.

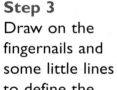

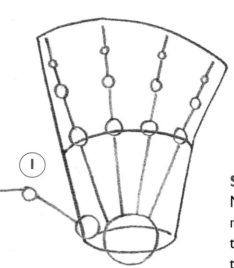

Step 2

Now outline the flesh and muscle around the bones. Look at the back of your own right hand to help you.

Step 3

Draw on the fingernails and some little lines to define the knuckles.

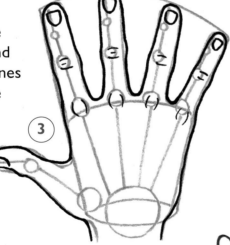

Step 4

Erase the lines and your drawing of the back of the hand is complete.

Step 5

To draw the other side of the hand, reverse the drawing you did in steps 1 and 2, then copy all the crease lines you can see here.

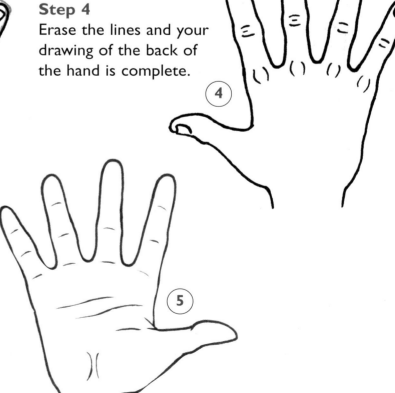

Hands in Action

In manga, hands are used as fists, levers and counterweights in fighting. They are also used for holding tools and weapons. They can convey a lot about the emotion of a character too.

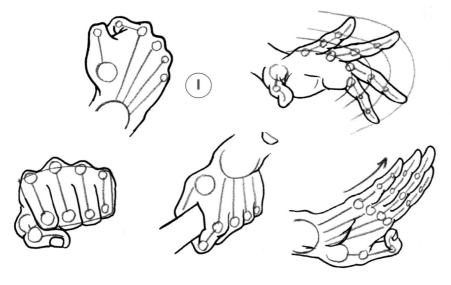

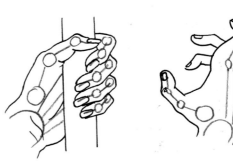

1 Poses
Here are some examples of Duke's hands in action. I've added some guidelines to help you draw them.

2 Simplifying hands
Some artists choose to simplify hands. There are several ways of doing this. Try out these different styles.

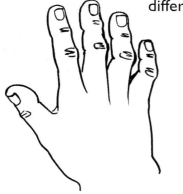

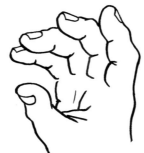

chunky hands

cartoon hands

3 Different ages
It's clear that these hands belong to characters that are very different in age. The baby hands are chubby, so the bones and joints aren't very defined. The older hands are much more bony and wrinkled.

baby hand

old hand

Proportions

Manga artists work out the relative sizes of their characters using head lengths. This is Duke at four different ages. As he gets older, the shape of his body changes.

1 Toddler Duke

This is Duke at about three years old. The younger a character is, the larger his head is in relation to the rest of his body. You can see from the guidelines that Duke's height is four times the height of his head. Manga children are quite chubby.

2 Preteens Duke

At nine years old, Duke is about six heads in height. His chest is becoming broader and he is generally more muscular.

3 Teenage Duke

Duke is now well into his teens. His muscles are now well developed. At seven heads in height, Duke is quite tall for his age. Some manga males are only about this height when they are fully grown.

4 Adult Duke

This is Duke at his adult height of eight heads. Male manga characters can be up to ten heads tall, but this tends to be the incredibly strong or evil ones. As well as having developed even bigger muscles, Duke has more flesh around the waist, making his chest less defined. His thigh muscles are also larger in relation to the rest of the legs.

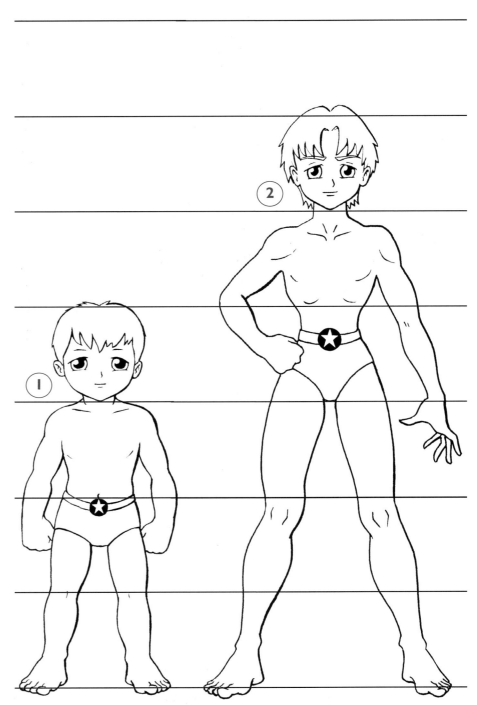

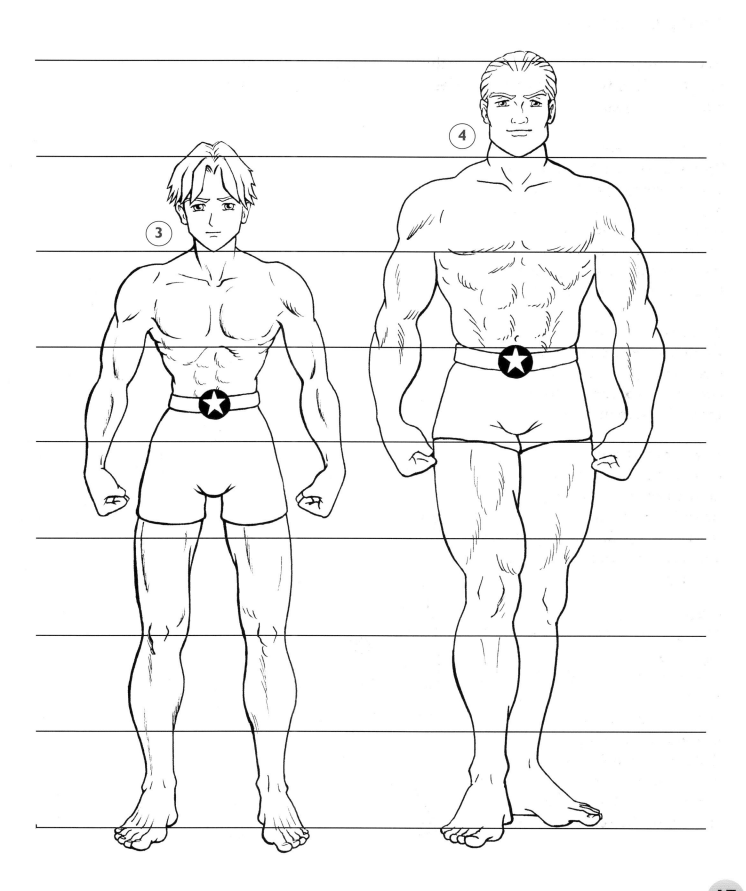

Colour

Now we're going to look at inking, colouring and applying tone to your drawings. Although adding colour can produce fantastic results, it can also ruin a good drawing if the colour isn't applied well. Spend some time experimenting with different materials to learn about the various effects that can be created with them.

Light and Shade

Making some parts of your drawing darker by shading them with pencil will create the illusion of solidity and depth. Don't get too carried away with your pencil. You should leave plenty of your paper uncovered since the lighter some parts of your picture are in relation to others, the darker and more dramatic the shadowy areas will look.

1 Lighting from the side

This is manga character Min. Here he's been shaded as if the light source is coming from behind his left shoulder. He is therefore more brightly lit on the right. The left-hand side and the parts of his body underneath wouldn't receive so much light, so they have been shaded darker.

2 Lighting from below

This time Min is lit from below right, which makes the image look more creepy. The bottom part of Min's face will naturally be brightly lit. The top and sides should therefore receive the heaviest shading. Use a soft pencil for this.

Inking and Colouring

There are many ways of colouring manga artwork, including painting and computer colouring. Two of the simpler methods are described here.

1 Finished pen line

Before starting on the colour, retrace the inked line of your drawing, varying the width of the lines to accentuate curves, and darkening edges which face away from the light source.

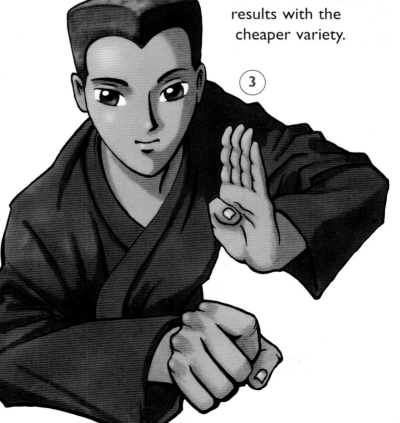

2 Coloured pencils

Once you've made a good solid outline of your picture, try adding some colour. Coloured pencils are easy to use and can look convincing if you use them wisely. The colours can be blended to create new ones. This has been done here by working one colour over the top of another.

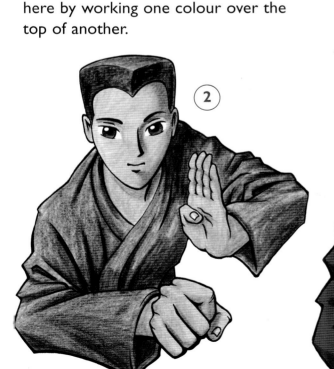

3 Felt-tip pens

Felt-tip pens produce vibrant results very quickly and are available in a vast range of colours. This picture was coloured using felt-tip pens of artist's quality, but they are very expensive. You can achieve similar results with the cheaper variety.

Action

Drawing action figures that look really convincing is all about capturing the shape and movement of the character's body. To get these right, you will need to increase your awareness of the body and how it behaves. To help you do this, we'll be studying some new poses. We'll also take a look at perspective and the technique of foreshortening, which you'll find useful for making your pictures look more realistic.

To draw convincing action figures, it is very important to start with light pencil lines. If you do this you'll be able to keep resketching until you get them absolutely right.

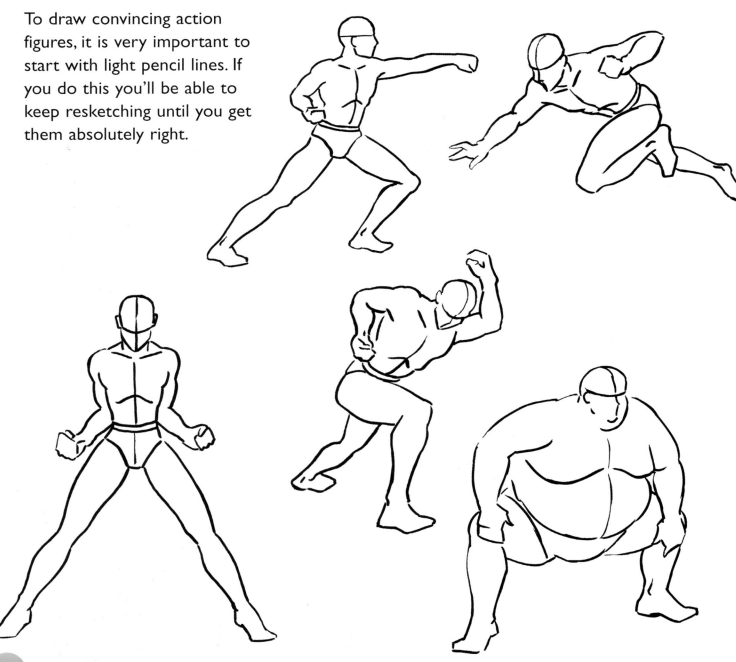

Action Poses

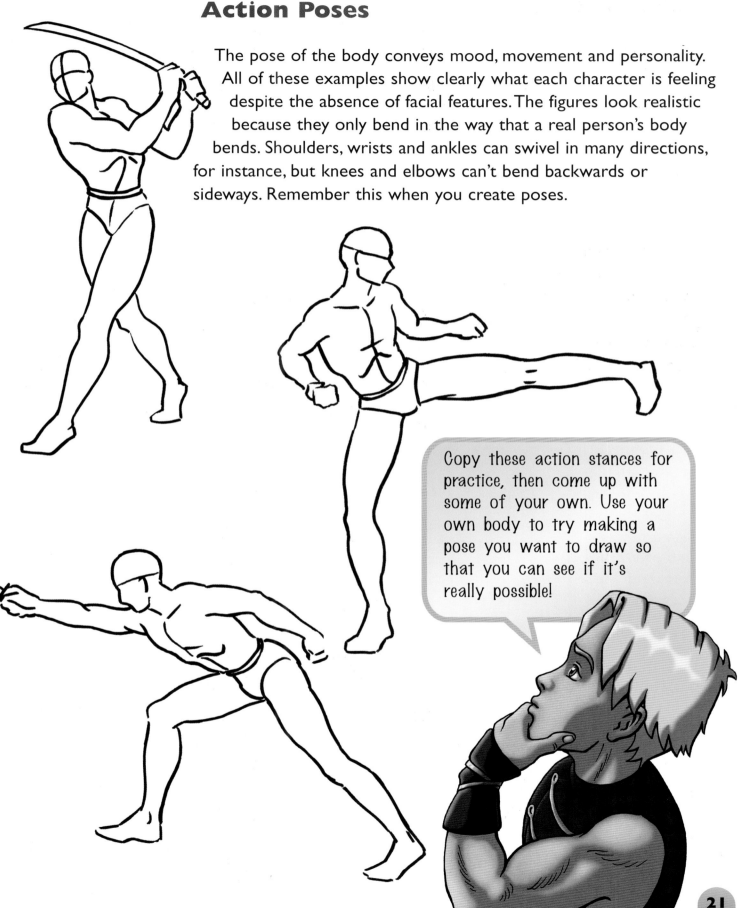

The pose of the body conveys mood, movement and personality. All of these examples show clearly what each character is feeling despite the absence of facial features. The figures look realistic because they only bend in the way that a real person's body bends. Shoulders, wrists and ankles can swivel in many directions, for instance, but knees and elbows can't bend backwards or sideways. Remember this when you create poses.

Copy these action stances for practice, then come up with some of your own. Use your own body to try making a pose you want to draw so that you can see if it's really possible!

21

Triumphant Warrior

In this exercise, we're going to draw a fully clothed, dramatically posed action character named Treen. The drawing involves a lot of the aspects we've covered so far, like pose, muscle build and dynamic hands. Take your time with each step.

Step 1
Draw the skeleton framework as shown. Copy the central lines on the body parts carefully. Look at how the position of the arms affects the shape of the shoulders.

Step 2
A lot of the body is going to be covered by clothing, but roughing out the shape will help you to draw the clothes. Copy the red lines as accurately as possible. Notice that Treen is much more heavily muscled than Duke.

Step 3
Rough in the shapes of the clothing and sword. Do some more work on the hands, then start placing the facial features. The hair should look as though it has been caught by a gust of wind. The waistcoat should be drawn with a texture to suggest fur.

Step 4
Now for some of the detail that really makes this triumphant stance. Add in the facial expression, the hair blowing across the face, and the strapping around the legs and wrist. Add detail to the clothing, shoes and sword, as shown.

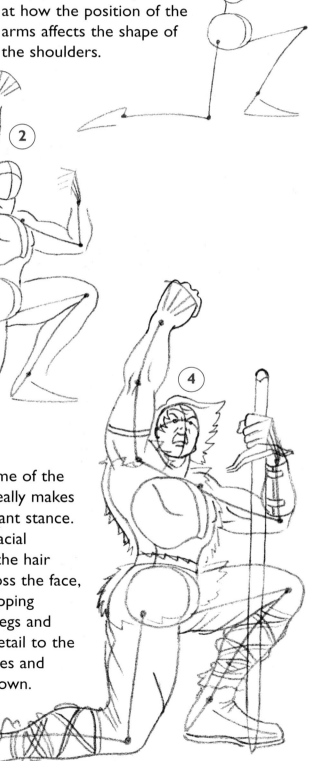

Step 5

Now that all the main guidelines forming your picture are in place, you can go over all your good lines in ink. Finish off the face and hair, add more detail to the handle of the sword, and bring out the texture of the fur. Copy the fold lines on the boots, and the definition on the backs of the hands.

Step 7

You can copy this colour scheme or use different colours and patterns. You might want to adapt the figure, changing the clothing or the expression. You could make the arms slimmer or more muscular.

Step 6

When the ink is dry, erase the rest of your pencil lines to leave a clean picture.

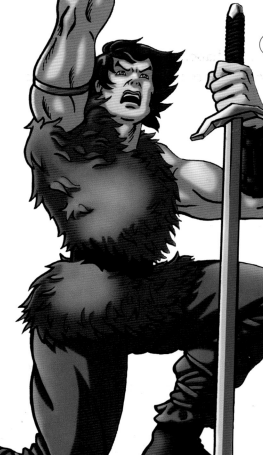

Perspective

When artists talk about perspective, they mean that objects look different according to the angle, height or distance from which we view them.

1 Eye level

This figure is viewed from the level of the hips as shown by the horizontal green line. This is known as the eye line. Features above this line appear to slope downward as they get further away from us, even though they are really level. Features below our eye line slope the other way.

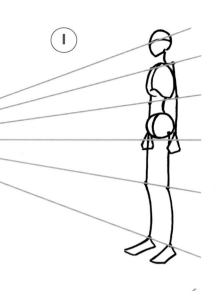

2–3 Changing eye level

In picture 2, our eye line is much higher. In picture 3 it is much lower. This affects the degree to which different parts of the body slope.

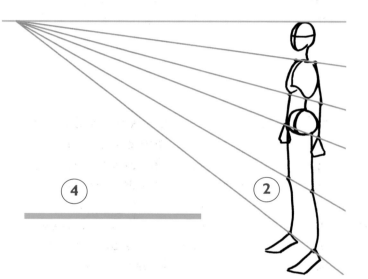

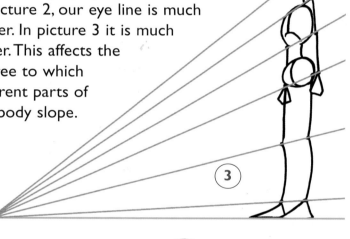

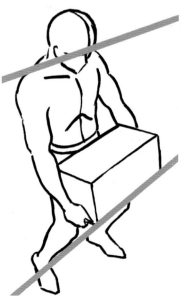

4–5 Different views

When we are looking down on a figure, as in picture 4, we can see more of the top of the head and shoulders, and less of the legs. When we look up at the figure, as in picture 5, the opposite is true. In both pictures, the horizontal green line shows the level from which the figure is viewed.

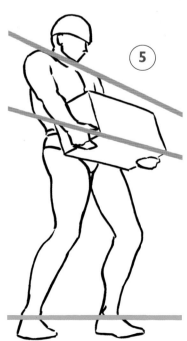

Foreshortening

Another technique that is used to make manga figures look more dynamic is foreshortening. This is when the parts of a figure that point towards us look shorter than the parts we see from the side. This can be confusing to draw but can give a picture real impact.

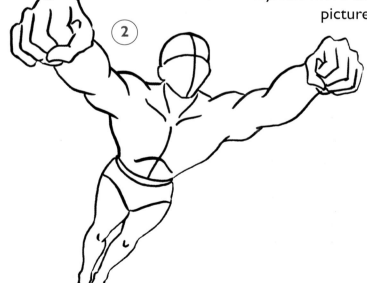

1 Side view

Picture 1 shows a flying figure drawn from the side. The lengths of the torso, arm and leg are all in proportion to each other, but the picture lacks dynamism.

2–3 Changing proportions

If we draw the same pose from a different angle so that it tilts toward us, as in pictures 2 and 3, the figure looks much more dynamic. You can see that the proportions of the various body parts have changed. The arms have been shortened, the hands enlarged, and the legs and feet made smaller. Although these proportions aren't correct, the figures look normal because the oversized parts look closer to us and the reduced parts look as if they are further away. The more the relative proportions are exaggerated, as in picture 2, the closer the figure will seem to us. The less the distinction between the large and small features, as in picture 3, the further away the figure will seem.

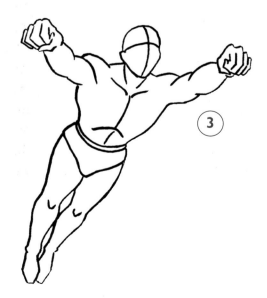

Throwing Boy

Now that you've learned some of the theory about perspective, let's try putting it into practice. Bear in mind that this young character, Kom, is viewed from a very low eye line, level with his ankles.

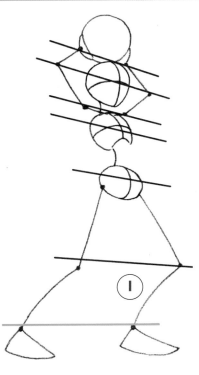

Step 1

Start by drawing the main body parts, then add the limbs. From this perspective the joints of one arm sit higher than those of the other, as shown by the receding lines. The ankle joints, however, should line up horizontally. The knee joints don't both sit on the receding line here since one leg is positioned further back than the other. The outlines for the feet should be quite large. Draw the ball as a simple circle.

Step 2

If you've drawn your skeleton framework accurately, adding the outline shape for the flesh and muscle should be easy. Kom is only a boy, so his muscles aren't well developed. Place the eyes at this stage.

Step 3

Start sketching in the clothing. Notice how the legs of the boots are large and angular. We are looking up at Kom, and he is also leaning backward slightly, so the shins and feet are drawn bigger so they appear closer to us. Place the rest of the facial features and the hair.

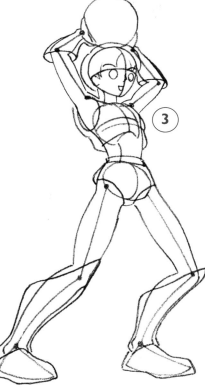

Step 4

Now for more detail. Work on the hair and eyes, then add all the lines that show the ribbing on Kom's spacesuit and boots.

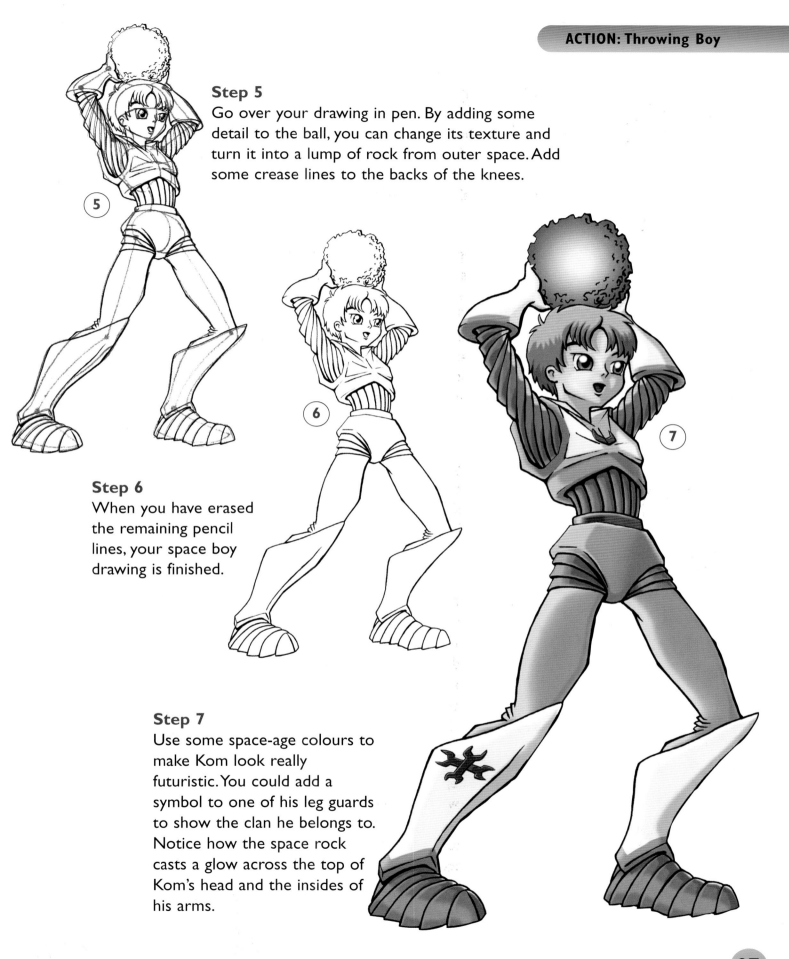

Step 5

Go over your drawing in pen. By adding some detail to the ball, you can change its texture and turn it into a lump of rock from outer space. Add some crease lines to the backs of the knees.

Step 6

When you have erased the remaining pencil lines, your space boy drawing is finished.

Step 7

Use some space-age colours to make Kom look really futuristic. You could add a symbol to one of his leg guards to show the clan he belongs to. Notice how the space rock casts a glow across the top of Kom's head and the insides of his arms.

Fighting Hero

Our hero Rik is set to throw a punch at a villain. It's not just his clenched fist that tells us this, it's his whole pose, including the expression on his face.

Step 1

Rik has swung back his arm, ready to land his punch, and his whole torso has twisted. The head and hips are side on while the chest is at a 3/4 angle. The forearm of the fist closest to us is very foreshortened, so don't even draw a bone for this. The lines forming the bones of the back leg are slightly shorter than those of the front one to make it look further away.

Step 2

Add the body outline. Use lots of overlapping curved lines along the arms to emphasize the strong muscles. The waist appears very slender, which helps to exaggerate the width of the chest.

Step 3

Draw the outline of the vest, belt and trainers. Then add the outline for the hair and work on the facial features. Shape the hands.

Step 4

Add some more lines to the hair. Draw the taut neck muscles. Now work on the clothes again, adding some fold lines to the back of the vest and where the jeans bunch up over the trainers. Draw some lines for the bandages across the fingers.

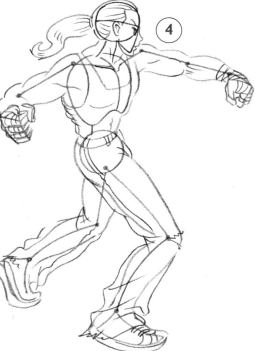

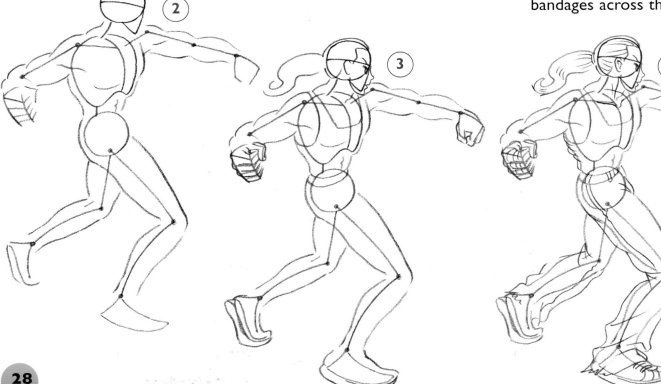

Step 5

Now go over the final lines of your drawing with a pen. Don't forget all the crease lines on the clothes and the extra little lines on the body that emphasize bone or muscle. Add the tread under the shoe and the trouser seamlines.

Step 6

Go over your final drawing in black felt-tip pen. When the ink is dry, erase all the pencil guidelines that formed your original framework. You can copy the colour scheme used here, or make up your own.

Manga clothes can say a lot about a character's personality and the world they live in.

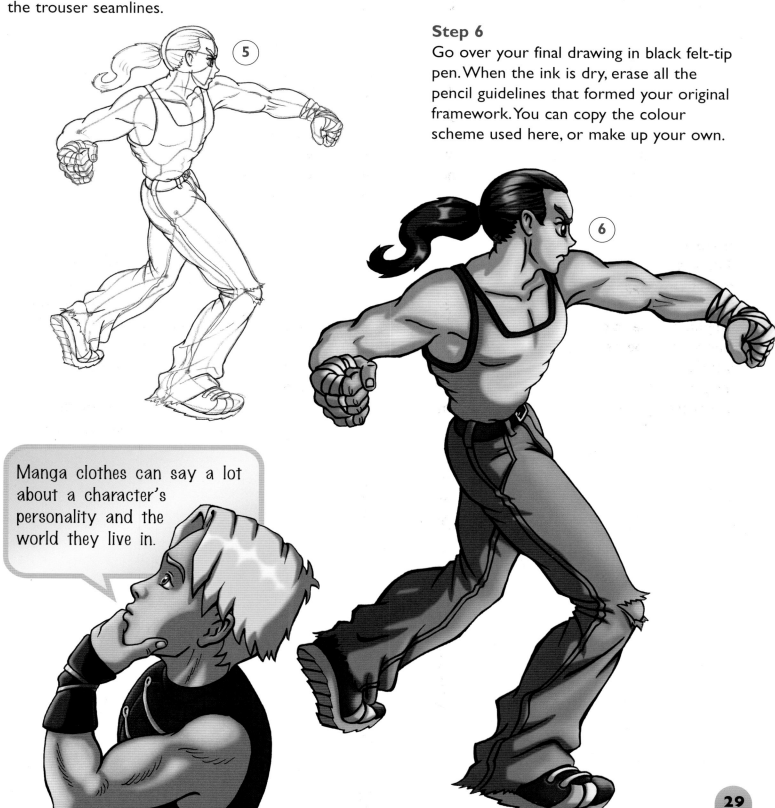

Glossary

angular Having angles or sharp corners.

counterweight A weight that balances another weight.

definition The clarity in outline of an object.

dynamic Full of energy.

foreshortening In drawing, making something appear shorter than it actually is in order to create a three-dimensional effect.

framework Structure.

highlight *verb* Draw attention to something, or make something particularly noticeable.

horizontal Parallel to the horizon.

joint Any of the parts of the body, such as the knee, wrist or elbow, where bones are connected.

lever Something that pivots on a point and is used to move or lift heavy loads.

manga The literal translation of this word is "irresponsible pictures". Manga is a Japanese style of animation that has been popular since the 1960s.

perspective In drawing, changing the relative size and appearance of objects to allow for the effects of distance.

proportion The relationship between the parts of a whole figure.

radiate Spread out.

receding Going back or down to a certain point.

relative Considered in comparison to something else.

shin The front portion of the leg from below the knee to above the ankle.

stance The way someone stands.

taper Become gradually narrower at one end.

texture The feel or appearance of a surface.

tone The overall blend of colour, light and shade in a painting.

torso The upper part of the human body, not including the head and arms.

vertical Upright, or at a right angle to the horizon.

watercolour Paint made by mixing pigments (substances that give something its colour) with water.

Further Information

Books

How to Draw Manga: A Step-by-Step Guide by Katy Coope (Scholastic, 2002)

How to Draw Manga: Compiling Characters (Volumes 1 & 2) by the Society for the Study of Manga Techniques (Japan Publications Trading Company, 2000)

Step-by-Step Manga by Ben Krefta (Scholastic, 2004)

The Art of Drawing Manga by Ben Krefta (Arcturus, 2003)

Websites

http://www.polykarbon.com/
Click on "tutorials" for tips on all aspects of drawing manga.

http://omu.kuiki.net/class.shtml
The Online Manga University.

http://members.tripod.com/~incomming/
Rocket's How to Draw Manga.

Note to parents and teachers:

Every effort has been made by the publishers to ensure that these websites are suitable for children and contain no inappropriate or offensive material. However, because of the nature of the Internet, it is impossible to guarantee that the content of these sites will not be altered. We strongly advise that Internet access is supervised by a responsible adult.

'Bye everyone! I hope you had fun learning how to draw manga.

Index